IMAGES
of America
Along the
Caloosahatchee
River

Even from space, the Caloosahatchee is visible winding its way through Southwest Florida from Lake Okeechobee to the Gulf of Mexico. (NASA.)

On the Cover: Taken near the now-vanished settlement of Rialto in 1885, before the Caloosahatchee River was dredged and channelized, this photograph shows one of the small boats that used the river as a highway through Southwest Florida. (Courtesy of the Hanson Family Archives.)

IMAGES
of America

ALONG THE CALOOSAHATCHEE RIVER

For Karen with my best wishes!!

Amy Bennett Williams

ARCADIA
PUBLISHING

Copyright © 2011 by Amy Bennett Williams
ISBN 978-0-7385-8747-9

Published by Arcadia Publishing
Charleston, South Carolina

Printed in the United States of America

Library of Congress Control Number: 2010937382

For all general information, please contact Arcadia Publishing:
Telephone 843-853-2070
Fax 843-853-0044
E-mail sales@arcadiapublishing.com
For customer service and orders:
Toll-Free 1-888-313-2665

Visit us on the Internet at www.arcadiapublishing.com

In memory of Charles Edgar Foster, the old Cracker river rat who introduced me to his beloved Caloosahatchee

Contents

Acknowledgments 6

Introduction 7

1. "In Days Agone" 11
2. Taming the Waters 27
3. Boats and Bridges, Cities and Characters 45
4. Life along the Caloosahatchee 93

Acknowledgments

Heartfelt thanks to Woody Hanson for generously sharing his family's singular archive of photographs and documents. Sara Nell Gran kindly allowed the use of her vintage postcards and family photographs. The Alva Museum, the Southwest Florida Museum of History, and the Southwest Florida Historical Society provided valuable research material. Following in the footsteps of the late Charles Foster, Rae Ann Wessel helped me put Caloosahatchee history and lore in context while immensely deepening my understanding of the river's dynamics. The first person who ever showed me the river up close was Chester Scheneman of Alva, who took me out for a life-changing afternoon spin in his little outboard fishing boat decades ago. Thanks to the many people who have offered their memories and stories of the river with me over the years, and thanks to the *News-Press*, which has allowed me to learn about and share Southwest Florida's rich history.

Unless otherwise noted, the images in this book appear courtesy of the Hanson Family Archives (HFA), Sara Nell Gran (SNG), the Alva Museum (AM), the Florida Photographic Collection (FPC), or the Uncommon Friends Foundation (UFF).

INTRODUCTION

It has mastodon bones under its bed—not to mention giant shark teeth and tiger skulls—all souvenirs of its wild youth. It has carried Calusa Indian war canoes, barges piled high with oranges, and a young Thomas Edison in search of rare tropical plants. Dolphins and manatees frolic and feed in its warm water, monster bass lurk in its quiet oxbows, and alligators sun on its banks.

Flowing 75 westerly miles from Lake Okeechobee to the Gulf of Mexico, the Caloosahatchee River is full of quirk and paradox yet is critical to the region it traverses. Without its waters, what people today know as Southwest Florida would not exist. Yet without people, the river known as the Caloosahatchee would not exist either.

When the ocean receded and the Florida peninsula emerged a million or so years ago, a chain of shallow ponds and lakes (some connected by seasonal creeks) remained in the long hollow of a subtle valley between a vast, remnant inland sea (Lake Okeechobee) and the Gulf of Mexico. From one of the lakes spilled a waterfall (an astonishing rarity in such flat country) that became a shallow, meandering river that slowly side-wound its way to the Gulf.

Years later, engineers and entrepreneurs would dynamite the waterfall, then dredge and ditch those ponds, lakes, creeks, and river together, until there was one navigable waterway running from the big lake to the Gulf.

Humans arrived late in the last ice age, about 10,000 years ago, when the region still supported creatures like mammoths, enormous sloths, and saber-toothed tigers.

Seafaring Spaniards, seeking gold and converts, arrived in the 1500s. They encountered several native groups dominated by the so-called fierce people—the Caloosa or Calusa—for whom the river is named (*hatchee* is the Creek Indian word for "river"). The Calusa or their precursors were the first humans to alter the river to their needs, digging a canal to bypass the waterfall. Yet just a few hundred years after Europeans arrived, the Calusa had almost entirely vanished, devastated by disease or exiled to Cuba, though many of their shell mounds and settlement sites remain on and near the Caloosahatchee and its estuary.

In the 1700s, another Native American group appeared in the region, a loose affiliation of Creek Indians who had left the lower South and became known as the Seminole. They settled around the river and in the Everglades. During the three Seminole Wars in the early and mid-1800s, the United States built several forts along the Caloosahatchee; some were reactivated during the Civil War.

In the mid-1800s, pioneer settlers began arriving. Some took over those now-abandoned forts, which is how the Caloosahatchee city of Fort Myers was born. Most pioneers depended directly or indirectly on the river for their livelihood: they fished it, shipped cattle and citrus on it, and homesteaded its banks. Most of the settlements that grew into the region's major towns and cities sprang up along its banks: Moore Haven, LaBelle, Alva, North Fort Myers, Fort Myers, and Cape Coral.

Fifth-generation Fort Myers native Woody Hanson, who grew up on the river, remembers exploring the winding coves of what later became the city of Cape Coral, catching snook and gathering scallops.

Woody Hanson's family has a generations-old claim on river history, too. His late mother, Mary Ellen Hanson, collected images and articles about its history and the surrounding region; many of the photographs in this book come from the Hanson family archive. Woody's paternal grandfather was the Seminole Indians' so-called white medicine man. And his great-great-grandfather Manuel Gonzalez moved to Fort Myers from Key West in 1866 to settle in the officers' quarters of the abandoned Caloosahatchee riverfront stronghold, now Fort Myers.

Gonzalez received the city's first land grant (riverfront property, not surprisingly) and opened one of the first trading posts in the area on the river. A skilled sea captain, he delivered mail from Tampa to Key West with stops up and down the Caloosahatchee, which served as a liquid highway to the state's interior.

The river also was the region's main transportation corridor for almost a century, carrying barges piled high with oranges, peppers, and sweet potatoes. Cattle destined for Cuba were pushed south in huge herds from the state's interior by scrappy, whip-wielding cowmen known as Crackers for the sound their leather whips made. When they reached Olga, about 25 miles upriver from the Gulf of Mexico, the Crackers urged the cattle into the Caloosahatchee and made them swim across. After crossing the river, they drove them on to Punta Rassa at the river's mouth.

Punta Rassa was the site of the former Fort Dulaney, which the US Army opened in 1837 to supply soldiers fighting the Second Seminole War. The hurricane of 1841 all but destroyed it, but the Army rebuilt it. During the Civil War, a sturdy addition on pilings was added to quarter the men who moved cattle destined for Key West. After the war, Punta Rassa became Florida's busiest cattle-shipping port, and the old wooden barracks were again pressed into service as a restaurant and overnighting spot for cattlemen.

Meanwhile, the International Ocean Telegraph Company (which later became part of Western Union) began work on an underwater Florida-to-Cuba cable via Key West in 1867. In 1898, Punta Rassa was the first US site to receive news about the sinking of the USS *Maine* in Havana Harbor, which helped ignite the Spanish-American War. Telegrapher George Shultz ran an ersatz bed-and-breakfast for cowmen on the side, though when tarpon fishing in the river region became fashionable, he converted the old barracks into a hotel catering to sports fishermen, the Tarpon House.

In 1885, Shultz received his most famous guest—Thomas Edison. The inventor had been vacationing in northern Florida when he learned of the state's wild southwest coast. He made his way to Punta Rassa, where if not for a quick-witted boatman named Nick Armeda, Fort Myers might never have won the heart of its most famous snowbird. According to Karl Grismer in *The Story of Fort Myers* (1982), Armeda was 16 and was working aboard the yacht *Jeanette* when Thomas Edison and two friends hired the ship for a cruise down the Gulf.

Armeda told Edison there was a cable office at Punta Rassa, piquing the interest of the inventor, who'd been a telegrapher himself. He asked to stop and look the place over, Grismer reports. Shultz, the station manager, "entertained him royally" and invited Edison to stay the night. According to Grismer, "The next day while sitting on the veranda smoking cigars, Shultz told Edison about [Fort Myers] . . . His curiosity aroused, Edison decided to see the village."

The rest, of course, is local history.

Always on the lookout for plants he could use as potential light bulb filaments, Edison embarked on a 12-mile trip upriver to the young town of Fort Myers and in short order, had bought a prime piece of riverfront acreage. He became the city's most famous winter resident; his home, along with Henry Ford's, who eventually bought the place next door, are now award-winning historic destinations and popular tourist attractions.

Human impacts to the river on a grand scale began a few years before Edison's arrival in 1881, when Philadelphia industrialist Hamilton Disston launched his first Florida project, the draining of the wetlands around Lake Okeechobee. Disston allied himself with prominent settlers and

eventually connected several of the smaller lakes to Lake Okeechobee, then dredged a canal from Fort Thompson to Lake Okeechobee, in the process destroying the waterfall at the river's headwaters. These large-scale alterations utterly changed historical water patterns. They created a channelized river where there had been none. They made suburbs and cities possible in what had once been swampland.

Yet, even with all the early-20th-century dredging and draining, the devastating hurricanes of 1926 and 1928 wreaked havoc on the region (Zora Neale Hurston's classic *Their Eyes Were Watching God* focuses on the storm of 1928), claiming hundreds of lives in Moore Haven and Clewiston. Clamorous demands for flood control reached Washington, DC, and in 1930, Congress authorized the start of a huge engineering project to build a dike around the lake and increase the Caloosahatchee's storm water carrying capacity.

In subsequent years, additional projects straightened and deepened the river further, making it the western leg of the Cross-State Ship Channel, which joins the Atlantic Ocean with the Gulf of Mexico by way of Lake Okeechobee. Two locks at Moore Haven and Ortona were finished in 1935, and two years later, the massive Herbert Hoover Dike around Lake Okeechobee was finished. Widening and re-dredging projects continued over the next three decades, and in 1966, the W.P. Franklin Lock and Dam opened, forever walling off the river's saline tidal waters from the freshwater portion.

The numerous locks, canals, and barriers built over the years to restrain the river created a perpetual need for repair, restoration, and improvement projects that continues to this day. As the late Caloosahatchee native son and scholar Charles Foster used to say, "It's the world's most sophisticated plumbing system."

Be that as it may, the Caloosahatchee has always been—and remains—an immensely appealing river. As the late librarian Irby Clay, who grew up along the river in Alva, recalled: "Every place on the river . . . huge oaks stretched their arms, draped in grey beards of Spanish moss and air plants. Tall, stately cypress trees reached skyward. Many varieties of water-loving flowers grew on the banks—white spider lilies, blue flags, hyacinths. When saltwater reached the river, we spent many hours at night fascinated by the phosphorous waterfire. Every sunken log, every fish or turtle that moved became a light of fire. After dark, the river was then an unbelievable paradise. Long ribbons of fire followed your boat or your hand as it was held in the water. This is one of the many beautiful things about the river I am thankful to have known."

One

"In Days Agone"

When naturalist W.S. Blatchley toured the Caloosahatchee region early in the 20th century, he found a slow-moving river winding through dense green wilderness. Newspaperman-turned-historian Karl Grismer described the river: "Widely acclaimed as one of the most beautiful rivers in the world. Great live oaks, hickories, willows, and magnolias stretched their branches out far over the water. . . . The trees were filled with flowering vines and air plants covered with beautiful red blossoms."

Recalling the river in his 1911 memoir *In Days Agone: Notes on the Fauna and Flora of Subtropical Florida in the Days when Most of its Area was a Primeval Wilderness*, Blatchley wrote: "The banks are very low and the mangrove, with its brilliant green foliage and numerous pendant aerial roots forms a dense barrier along most of the riverfront. Where the cabbage palmetto grows close to shore its huge cone of rootlets were usually covered with a dozen or more large cooter turtles which let go all holds and tumbled off when our boat drew near. Alligators began to appear, a half dozen or more sometimes being seen in an hour."

Native American groups had lived near and used the river for centuries; the word *Caloosahatchee* means "river of the Calusa," an influential Indian nation that wielded power from its base in the Caloosahatchee region.

When European pioneers began arriving in the 1800s, they set to work clearing portions of its banks for croplands and settlements. When Blatchley returned to the area in 1918, he was astonished at the changes. "The scenery along the river has changed much, and for the worst since I last saw it," he wrote. "Many of the fine cabbage palmettos have been cleared away for the truck gardens of northern settlers. The villages have grown in size, but their shoreline is now filled with dilapidated or half-sunken boats and other debris of civilization."

As humans continued to alter the river to suit themselves, Blatchley's nostalgia for the old, wild river would be echoed by myriad others.

Millions of years ago, the region through which the Caloosahatchee runs was covered with a shallow sea. This cast of a conch shell is typical of the fossils found in the sediments under and around the river. (HFA.)

Alligators have always prospered in the Caloosahatchee's waters. In the early 20th century, naturalist W.S. Blatchley marveled at the number he encountered on a trip up the Caloosahatchee: "A half dozen or more sometimes being seen in an hour." (SNG.)

The river's many meandering curves made traveling it by boat a challenge. Pilots had to master the art of wrap-around navigation, which required nosing the boat's bow up onto the bank, roping it to a tree, pulling the boat around the bend, and repeating the process until the whole curve had been traversed. (HFA.)

Before entrepreneurial developer Hamilton Disston began dredging the river in 1881, its headwaters were near Lake Flirt in what is now Hendry County. During the rainy season, water spilled from the lake down small rapids (visible in the background of this postcard) and then began its slowly winding course to the Gulf of Mexico. (SNG.)

Originally, many places along upriver Caloosahatchee had sandy, gently sloping banks, often thickly forested with sabal palms and live oaks draped in climbing vines. The late Alva resident Charles Foster recalled being able to fill a canoe with the wild grapes that could easily be plucked from vines hanging overhead. (HFA.)

Difficult as it sometimes could be to travel, the Caloosahatchee was renowned for its scenic beauty and was the subject of many picture postcards. (SNG.)

ON THE CALOOSAHATCHEE, FLA.

Before the Caloosahatchee was straightened, there were more than 100 winding twists and turns in the stretch from Fort Myers to Lake Okeechobee alone. (HFA.)

A Turn in the Upper Caloosahatchee

Before urban development crisscrossed it with canals and streets, mangrove-fringed Redfish Point on what is now Cape Coral was an isolated Caloosahatchee outpost. (HFA.)

Fort Denaud in Hendry County was named for French Canadian trapper Pierre Denaud, who lived along the Caloosahatchee in the mid-1800s. The fort was established in 1838 and was used intermittently during the Seminole Wars. (HFA.)

Until 1924, when Fort Myers got its first bridge, this small wooden bridge at Alva, which dates to about 1903, was the westernmost crossing of the Caloosahatchee. A new swing bridge replaced it in 1925, and the old one was taken apart and moved to Matlacha. Alva's old bridge served Matlacha for just one year until the 1926 hurricane finished it off. (SNG.)

This bird's-eye view of the Caloosahatchee dates from 1920s. Visible are the palms that were once so abundant and several structures. (HFA.)

When a hurricane destroyed Fort Dulaney at the mouth of the Caloosahatchee during the Second Seminole War, the Army built Fort Harvie at a safer location about 15 miles upriver. Completed in 1841, it was abandoned after the war ended. When the Third Seminole War ignited, the site was renovated and renamed Fort Myers in 1850. This is the fort's sturdy blockhouse. (FPC.)

The same sandy soil that supports sabal palms and saw palmettos proved ideal for citrus crops as well. Early settlers often cleared the land and planted trees right up to the riverbanks, as the young grove visible at right illustrates. (HFA.)

This early aerial photograph shows the Fort Myers riverfront in the 1920s. The area is quite developed at this time; visible signs include those of a grocery and a real estate office. (HFA.)

Many of the region's pioneers built their houses as close to the Caloosahatchee as possible to reduce the distance needed to haul supplies home. The river's periodic flooding, however, made this a risky strategy, and many families had to start over after floods washed away their buildings. (HFA.)

The young men in this undated photograph worked at one of the many packinghouses along the Caloosahatchee in the early part of the 20th century. (Courtesy of Lorraine Norman.)

This early aerial photograph of Fort Myers shows the many piers and docks jutting into the river from downtown. Commercial fishing, along with fruit and vegetable packinghouses, was a major part of the young river city's economy. (HFA.)

The golden age of the Caloosahatchee steamboat lasted only about three decades, but it opened Southwest Florida to visitors from the North like Thomas Edison, who arrived by steamer in 1885. Much faster than crafts that needed wind or rowers to power them, steamboats soon became the transportation of choice up and down the Caloosahatchee River. J. Fred and Conrad Menge had the *Suwanee* built in Apalachicola, Florida, to carry freight and passengers—including honeymooners Thomas and Mina Edison in 1886. (FPC.)

Beginning its celebrated life in 1898 when it opened as the Fort Myers Hotel, this four-story waterfront luxury lodging changed its name to the Royal Palm and remained the city's premiere hotel for decades. Boasting a swimming pool, tennis courts, and a pier with spaces for guests to keep their yachts, it attracted well-heeled guests escaping the cold North. (HFA.)

Just as spectacular a catch as the Caloosahatchee area's famed tarpon, the small-tooth sawfish (a type of ray) was once commonly pulled from the river. Scientists from government and nonprofit agencies are now studying sawfish to help rebuild the population. (HFA.)

Two

Taming the Waters

The Caloosahatchee River is evidence of human determination. The river's course from Lake Okeechobee to the Gulf of Mexico is man-made—a testament to the power of will and technology to create a waterway nature never intended.

Since before recorded history, people have altered the Caloosahatchee. Ancient Indians with no more at hand than wood, shells, and bone carved a canal to skirt rapids at the river's headwaters in what is now Ortona in Glades County. And starting in 1881, an army of workers and machinery began joining the river to Lake Okeechobee, ultimately creating a seamless liquid freeway from one side of Florida to the other.

But more important than navigation in the mind of the public was flood control—especially after a series of devastating hurricanes in the early 20th century underscored the urgency of increasing the river's drainage capacity.

As Zora Neale Hurston wrote about the 1928 hurricane in *Their Eyes Were Watching God*:

> It woke up old Okeechobee, and the monster began to roll in his bed. . . . Under its multiplied roar could be heard a mighty sound of grinding rock and timber and a wail. . . . People trying to run in raging waters and screaming when they found they couldn't. . . . Ten feet higher and as far as they could see, the muttering wall advanced before the braced-up waters like a road crusher on a cosmic scale.

Casualty estimates range into the thousands. Restraining the lake while making the Caloosahatchee a relief valve became a national imperative. After passionate lobbying, even though the country was in the grip of the Depression, Congress signed off on a massive project to contain the deadly waters. There would be a huge earthen dike built around the lake and more dredging of the Caloosahatchee to increase its ability to carry away storm water.

This project and others further changed the river—dams and locks at Moore Haven and Ortona went up in the 1930s, and by 1966, the W.P. Franklin Lock and Dam had effectively detached the river's tidal saltwater portion from the upper reaches of its fresh water.

The 1928 hurricane flooded downriver cities like Fort Myers as well, where buildings blew apart and streets were underwater. (HFA.)

In the aftermath of the 1928 hurricane, federal troops and corps of locals spent months burying victims, sometimes in mass graves. Not everyone was immediately found, though, as this grim portrait of an unidentified survivor shows. (Author's collection.)

More than 2,000 people died in the hurricane of 1928, which tore through the Lake Okeechobee and Caloosahatchee region. This monument to the storm victims by sculptor Ferenc Varga was dedicated in 1976. It stands in front of the lakefront city of Belle Glade's municipal complex. (SNG.)

Rather than an environmental treasure, Florida's wetlands, including the Everglades and the Caloosahatchee, were viewed as a problem for much of the 20th century, considered a barrier to human enterprise that had to be conquered or "reclaimed," as this 1912 postcard shows. The following year, the Florida Everglades Engineering Commission said in a statement: "Drainage of the Florida Everglades is entirely practicable and can be accomplished at a cost which the value of the reclaimed land will justify, the cost being very small." (FPC.)

For riverfront towns, floods were a fact of life. In this 1913 photograph, a man points to a high-water mark in downtown LaBelle. (FPC.)

This is how downtown LaBelle looked around 1910. A wooden retaining wall separates the Caloosahatchee from the land. (FPC.)

In Moore Haven, the Caloosahatchee meets Lake Okeechobee. Flow between the two is regulated by the US Army Corps of Engineers. In addition to Lock and Dam No. 1, shown in this 1924 panorama, the Corps of Engineers operates two more along the river at Ortona and Olga. (FPC.)

The Caloosahatchee has undergone many bouts of dredging and straightening since the 1800s. In the 1960s, the river was widened and deepened. This photograph, taken near LaBelle, shows the massive dredge with the boat behind it from which spoil material was pumped into floating pipes and deposited as much as half a mile from the river. (Author's collection.)

One of Fort Myers's earliest subdivisions, Dean Park, was built by Rhode Island–born John Morgan Dean around 1900. "When Dean bought this tract," wrote historian Karl Grismer, "it was low and swampy and flooded by the backwash of the Caloosahatchee when the tides ran high. It was not a pretty place." But Dean bought a dredge and pumped in 150,000 cubic yards of sand to build up the land. Even so, the neighborhood flooded periodically, as this 1926 photograph shows. (HFA.)

A 1974 flood in Fort Myers drove the river into the front yards of homes in Fort Myers, much to the delight of the neighborhood ducks. (HFA.)

Boats move through the Franklin Lock at Olga, which allows them to cross from the Atlantic to the Gulf of Mexico via Lake Okeechobee and the Caloosahatchee River. (HFA.)

Screened barriers in front of the spillway at the W.P. Franklin Lock help keep manatees from the fast-moving water. (Author's collection.)

Workers pull up the flood gates at the W.P. Franklin Lock. The lock's moving parts must be cleaned, repaired, and refurbished periodically. (Author's collection.)

The US Army Corps of Engineers spent about $550,000 to build the lock and dam at Moore Haven in 1935. (HFA.)

This photograph shows the Moore Haven lock shortly after it was built in 1935. (HFA.)

Dick Starkey, lockmaster of the W.P. Franklin Lock and Dam in Olga, is pictured on the job in 1981. (Author's collection.)

The Moore Haven Lock between Lake Okeechobee and the Caloosahatchee in Glades County was built in 1935 by the US Army Corps of Engineers. It is the first of three locks and dams along the Caloosahatchee; the one at Ortona is 15 miles downstream, followed by the W.P. Franklin Lock and Dam at Olga. (HFA.)

The Caloosahatchee begins in Moore Haven, where a dam separates it from Lake Okeechobee. The US Army Corps of Engineers periodically releases lake water into the river to relieve pressure on the aging earthen Herbert Hoover Dike. (HFA.)

Four spillway gates at the Ortona Lock provide additional flood discharge capacity, with a navigation lock located alongside the spillway, which is overlooked by the lockmaster's house. The US Army Corps of Engineers built the lock and dam at Ortona in 1937 to help regulate river flow between Lake Okeechobee and the Gulf of Mexico. (US Army Corps of Engineers.)

Workers monitor water rushing through the spillway at the Ortona Lock and Dam around 1980. (US Army Corps of Engineers.)

Before the lock was built between the Caloosahatchee River and Lake Okeechobee, boat captains used this tree, known as the Lone Cypress and the Sentinel Cypress, as a landmark to find the place where the Caloosahatchee entered the lake. Now considerably larger than it was in the 1925 photograph, the tree still stands in downtown Moore Haven, surrounded by concrete at its once-waterfront spot. (FPC.)

Three

BOATS AND BRIDGES, CITIES AND CHARACTERS

With tree-trunk canoes, paddle wheel steamboats, and luxury cruise liners, people have navigated the Caloosahatchee in all manner of watercraft over the years.

Before the advent of the automobile, boats were key to transportation in Southwest Florida. They carried children to school, cattle to market, and citrus crops to packinghouses. Most of Southwest Florida's major settlements began alongside the river, and most remain near the river to this day. Moore Haven, LaBelle, Fort Myers, North Fort Myers, and Cape Coral are all river cities. While less critical economically than in decades past, the Caloosahatchee is still an important part of their identities.

Other river settlements have faded into ghost towns, though some of their names remain on old maps: Goodno, Owanita, Upcohall, and New Prospect.

The people who staked their claims along the river have been a diverse a cast of characters indeed: Union and Confederate soldiers, cattlemen and crabbers, industrialists and inventors.

Useful as the Caloosahatchee has historically been to those who live near it, its waters have been a barricade too. More than a mile wide in some parts, the river effectively isolated many of the region's communities and people. Until, that is, people started building bridges. From hand-hewn wooden plank bridges to the mechanized drawbridges that dot its length today, the Caloosahatchee's crossings made the surrounding region infinitely more able to support growth and development.

Led by a Civil War widow who arrived by oxcart from Georgia in 1876, the English family settled along the Caloosahatchee near Fort Denaud until a flood forced them from that location. They then moved west to Alva, where they grubbed the land clear and planted citrus. There were setbacks; this 1912 photograph shows John C. English examining a tree that was killed when the Caloosahatchee overflowed its banks. Undaunted, the family replanted and continues to raise citrus on the land to this day. (FPC.)

After settling in Alva, the English family built a house of native heart pine on a bend in the river. This is how the house looked in the 1890s; over the years, the family added on and renovated it, but the central portion of the home survives. (HFA.)

After working with Hamilton Disston dredging the Caloosahatchee River, the Menge brothers—Conrad and J. Fred—began running passengers and cargo up the Caloosahatchee. They bought the *Anah C.*, their first steamboat, in 1888 and eventually had a fleet of eight vessels. (HFA.)

Built in 1906 in Kissimmee, the steamboat *Success* plied the Caloosahatchee during the heyday of riverboat traffic. In a 1966 article in the magazine *Tequesta*, Edward Mueller wrote that the *Success* "took fish to Fort Myers from the Lake (Okeechobee). When she burned in 1907, she was loaded with fish—what a smelly fire that must have been!" (FPC.)

It was three years in the making, but the drawbridge at Alva, finished in 1969, is still holding up after more than 40 years. (FPC.)

This modern drawbridge at Alva took three years to build before it opened in 1969. (FPC.)

This 1900 portrait shows the Menge brothers' *Uneeda* steaming up the Caloosahatchee. (FPC.)

According to the Florida Photographic Collection, this photograph from about 1890 shows the steamboat *Poinsettia* moored beside the Duval Warehouse on the Caloosahatchee at Fort Denaud. (FPC.)

Until the river was bridged, ferries like the one shown at Alva in 1895 were the only way to get vehicles like this convertible oxcart across the river. (FPC.)

Danish sea captain Peter Nelson arrived in Southwest Florida in the mid-1800s. Rumor had it that he was the King of Denmark's illegitimate son. Whether or not that was true, Nelson had enough money to buy enough riverfront land to lay out a town of his own. Stories say he called it Alva after a small white flower he found growing on the Caloosahatchee's banks that reminded him of one from his homeland with the same name. He planned his town to include parks, a library, and a school. This wooden building was eventually replaced with a two-story brick building that is still standing and in use. (AM.)

Charles Foster, who grew up along the Caloosahatchee River in Alva, was a lifelong educator and one of the river's most ardent champions. He helped found the nonprofit community group Riverwatch. (Author's collection.)

Until 1966, Alva had a swing bridge instead of a drawbridge. When a boat needed to pass, a section of the bridge would rotate open to allow the boat passage through the bumpers on the right side. (US Army Corps of Engineers.)

For decades, single-hulled barges carried fuel oil up the Caloosahatchee to the Florida Power & Light (FPL) plant located at the Caloosahatchee's confluence with the Orange River. There was never a major accident or spill, and the plant has since converted to natural gas. (AM.)

The Fort Myers Yacht Basin, which is still operating, was a Depression-era Works Progress Administration project. Built over two years—1937 to 1939—it provided local residents with valuable jobs. (HFA.)

Connecticut-based American Cruise Lines' *Savannah* traveled the Caloosahatchee in the 1980s, promising passengers, "After sailing along the shady, moss-draped Caloosahatchee River, the ship docks at Fort Myers, where guests can experience museums and tropical flora and fauna." (HFA.)

Fort Myers's riverfront Centennial Park is bounded on its east and west sides by bridges arching over the Caloosahatchee. (HFA.)

Born in Georgia in 1813, Francis Asbury Hendry was a Civil War captain turned cattleman who moved his family to Fort Myers in 1870 and drove his cattle across the Caloosahatchee River to Fort Thompson. He was known as the "Cattle King of South Florida." In the late 1880s, Captain Hendry and his wife sold their Fort Myers home to son Louis and moved to what is now Hendry County, where the captain helped plan the town of LaBelle. Legend has it that he named it for his daughters Laura and Belle. (SNG.)

Before they moved to Fort Myers, Capt. Francis Asbury Hendry and his family lived in this LaBelle home on the banks of the Caloosahatchee. The family saga has all the earmarks of a sweeping epic: gritty pioneers, maverick lawmen, and county-building visionaries soldiering on through war and peace and famine and feast. Many in the clan make their living and raise their children no more than an hour's drive on today's roads from the homesteads of their ancestors. (SNG.)

Francis Asbury Hendry married Georgia-born Ardeline Ross Lanier in 1852. They made a life on Southwest Florida's frontier, and she gave birth to 11 children, one of whom died in infancy. She was 83 when she died in 1917 in Fort Myers. Her brother-in-law George W. Hendry said of her, "She has ever been a woman of firmness and decision, yet gentle and affable. She has made Captain Hendry a life partner of the highest praise." (SNG.)

Francis Asbury Hendry arrived in Florida in 1851 when he was 19, then set about becoming one of the state's most influential residents. Not the least of his accomplishments was siring 11 children. (SNG.)

The Hendry family still plays a vital role in the life of the Caloosahatchee region. In this 1975 photograph, Jody Hendry rounds up horses on the Buckingham ranch, which hosted well-attended family reunions for years. (SNG.)

When Hendry County was created in July 1923, residents threw a big community barbecue celebration in the riverfront LaBelle City Park, which later was renamed Barron Park to honor one of the city's pioneer families. It's still a favorite place for picnics and watching river traffic. (HFA.)

This postcard shows the original swing bridge at Fort Denaud in what is now Hendry County. (HFA.)

Fort Denaud's old swing bridge, pictured in this undated photograph, was condemned and replaced in 1963 with a repurposed swing bridge that came from Pompano Beach. It is one of the few remaining swing bridges in Florida. (HFA.)

When Wisconsin-born Edgar Everett Goodno arrived in Florida in 1897, he began buying up vast tracts of land in the LaBelle area, including the Hendry family's ranch house. Goodno restyled the rambling wooden building into the well-appointed Fort Thompson Park Hotel, which opened in 1906. (HFA.)

On the banks of the Caloosahatchee near the site of Fort Thompson, Edgar Everett Goodno began farming and built a luxurious (for its day) two-story hotel, the Fort Thompson Park Hotel, which opened in 1906. (HFA.)

Edgar Everett Goodno raised cattle around the rural settlement (now a ghost town) that still bears his name, shipping them to market on rails that ran through the town center. When he died in 1936, his obituary in the *Fort Myers News-Press* noted, "His best-known venture as a cattleman was importing a herd of sacred Brahman bulls from India. Today, the result of the importation of these large, hump-backed cattle can be seen on the stock of Southwest Florida." Though most of Goodno was destroyed in the devastating 1926 hurricane, an abandoned general store building and the railroad grade remain. (HFA.)

An undated early view shows the Fort Denaud swing bridge that crosses the Caloosahatchee in Hendry County west of LaBelle. (HFA.)

At the end of his life, Alva's founder, Capt. Peter Nelson, lived in isolation on the island of Cayo Costa after the humiliation of being removed from the Lee County Commission because of his whiskey drinking. (AM.)

Flora English (left) was about 14 and Louise Bonniwell (right) was about 15 when this picture was taken in the English family's citrus packinghouse. (FPC.)

This photograph from about 1909 shows young Alva women Louise Bonniwell (left) and Flora English (right), who would have been about 18 and 17, respectively. (FPC.)

Pictured is Alva's first store in 1886. This site, which was the ferry landing, is now the end of the bridge. According to the caption on the photograph, the men pictured include Judge Williams, Ben Clay, Tom Hickey, and Jack Clay. (AM.)

This is a 1916 view of what is now Broadway in Alva at the north end of the bridge. From left to right, the buildings are Heitman Store, Ramsay Store, the Market, Mr. Parkinson's office, and the Alva school. (AM.)

Early Caloosahatchee River captain Manuel Gonzalez's children and family members include, from left to right, (first row) Lavenia Gonzalez and Laura Murray; (second row) Lee Murray, Odulia Gonzalez, Edward Gonzalez, and Mary Gonzalez; (third row) William Gonzalez, Louis Stewart, Laura Gonzalez, and Alfonso Gonzalez. (HFA.)

Built on land donated by Capt. Peter Nelson, Lee County's first masonry school was built in Alva with bricks made from sand hand-dug from the English homestead. The schoolyard had to be fenced to keep cattle from wandering in. (HFA.)

Capt. B.F. Hall built the steamboat *Corona* in Alva in 1900 and used it until the 1920s. This photograph of it from the Alva Museum archives has numbers written above some passengers' heads. According to the list of names, the people include (3) Mrs. Hall, (5) Mrs. Lee, (6) B.S. Clay, (7) Mrs. Bertha Hickey, (9) Mrs. Carrie Wilkinson, (11) Joe Lewis, (12) Mr. Surrency, (13) Lee Edwards, (21) Elias Edwards, and (22) Captain Hall. (AM.)

The handwriting on the back of this photograph says, "First Alva School on the south side of the river, later used as a church. A church group about 1901." (AM.)

"Alva School, built in 1888—slatted to cover cracks. Located on the 'park' near oxbow south of the plat," according to the inscription on the back. The typed caption on the back of this photograph reads: "One of North Alva's First Schools about 1900. Doorway: Flora English, Susie (Mrs. Sam) Bruton, Carrie. Standing left: Sue Hagen, Maimie Edwards, Sally Ferrell, Mamie Dodd, Sue Montgomery, Lillah Montgomery, Harvey Montgomery, Mary Stebbins. Sitting: Cecil Parkinson, Frank Parkinson, Henry Dodd, and Maurice English." (AM.)

This man is known as Captain McKinley, but sources don't agree on whether he went by the initials J.B. or the name Williams. Local legend had it that he fought in the Union army during the Civil War and became a streetcar manager in Washington, DC, before coming up the Caloosahatchee on Capt. Peter Nelson's boat *Spitfire*. He settled in Alva, where he ferried cattle across the river. He also planted a citrus grove that he watered with a steam-powered irrigation system. McKinley married Elizabeth English, and when she died in 1885, he moved across the river to live with her family for the rest of his life. (FPC.)

Alva's modern bascule drawbridge replaced the quaint swing bridge (below) in 1969. (FPC.)

Until a barge full of rocket parts bound for the Kennedy Space Center crashed into it in 1966, the Alva swing bridge lent old Florida charm to the town's landscape. (HFA.)

In the early 1900s, the downtown Caloosahatchee riverfront of the young city of Fort Myers was dominated by piers and packinghouses as well as the striking contours of its famous Royal Palm Hotel. (HFA.)

This photograph shows the downtown Fort Myers waterfront before the bridge over the Caloosahatchee from Fort Myers to North Fort Myers went up. (HFA.)

In 1962, Fort Myers's riverfront profile changed dramatically when a new fixed-span bridge over the Caloosahatchee linked it to North Fort Myers. (HFA.)

In his lab behind his Caloosahatchee riverfront winter home in Fort Myers, Thomas Edison experimented with sap of various plants in his quest to develop a domestic source of rubber. This photograph is dated April 4, 1912. (HFA.)

Fort Myers's Centennial Park runs along the Caloosahatchee and includes this sculpture entitled *Uncommon Friends* by D.J. Wilkins. It honors winter residents Thomas Edison and Henry Ford, who are said to have enjoyed Florida camping excursions with their friend and fellow industrialist Harvey Firestone. The sculpture shows them surrounded by Florida animals including alligators, manatees, and fish while relaxing at a campsite. (Author's collection.)

Thomas Edison's wife, Mina, loved gardening in her subtropical winter home. She was a founding member of Fort Myers's garden club and an active birder. To offer protection from marauding cats, she had birdhouses installed on posts in the Caloosahatchee River. (HFA.)

At the south end of this early plat map of the Caloosahatchee riverfront of Fort Myers is the property Thomas Edison bought in 1885. (HFA.)

In 1924, this wooden bridge—the first between Fort Myers and North Fort Myers—opened. It lasted less than three decades, burning in the early 1940s. The Tarpon Street Pier now occupies part of the bridge's original footprint. (HFA.)

The Caloosahatchee empties into the Gulf of Mexico at Punta Rassa. Until a bridge was built to Sanibel and Captiva, ferries like this one carried cars, passengers, and supplies to the islands. (HFA.)

Louisiana-born brothers Conrad and J. Fred Menge worked with Hamilton Disston to dredge the Caloosahatchee and connect it to Lake Okeechobee in the late 1890s. Eventually, the two built the prosperous Caloosahatchee River Steamboat Line, which included this stern-wheeler, the *Thomas A. Edison*. It carried passengers, mail, and cargo until it burned in 1914. (HFA.)

Colorful and adventuresome heiress Mona Burroughs Fischer came to Fort Myers with her wealthy family to live in a Caloosahatchee riverfront mansion in 1919. (UFF.)

In 1898, the three Caloosahatchee riverfront acres on which the Burroughs Home now stands sold for $3,500. A few years later, the 21-room, 6,000-square foot Georgian Revival mansion was built for $6,000, mostly with slash pine barged across the river from the Slater sawmill in what is now North Fort Myers. So grand an event was the mansion's construction that the *Fort Myers Press* published regular updates on its progress. (UFF.)

Captioned, "City of Louisville," this screened-in boat was tied up at the Fort Myers city docks. (HFA.)

Owned by the Menge brothers, the *Suwanee* traveled the Caloosahatchee in late 1800s and early 1900s. One of the most famous vessels in the Menge line of steamers, it was taken by Thomas Edison and his bride, Mina, en route to their honeymoon to Fort Myers. (HFA.)

Founded by James Moore in 1915 on the banks of the Caloosahatchee, the city of Moore Haven was bedeviled by a number of setbacks early in its history. In 1921, a fire ravaged most of its downtown buildings; in the midst of rebuilding, the 1926 hurricane dealt it another blow, destroying more than half of its buildings and killing some 200 residents. To the rescue came Marian Horwitz O'Brien, the first woman mayor south of the Mason-Dixon line, who got the city back on its feet and rebuilding yet again. (Author's collection.)

Steamboats like this ferried people up and down the Caloosahatchee for business and pleasure alike. (HFA.)

In 1866, Spanish sea captain Manuel A. Gonzalez arrived in Fort Myers from Key West with his uncle, a family friend, and his son-year-old son. They moved into the abandoned military fort, and Gonzalez opened the city's first general store. The site on which he built his home in downtown Fort Myers eventually became the Atlantic Coast Line railroad depot. His descendants live in the area to this day. (HFA.)

Little-known these days except to those who live there, the riverside hamlet of Olga has a rich history of farming and cattle ranching. It also offered travelers a Caloosahatchee bridge crossing until 1969, when the W.P. Franklin Lock opened and the bridge was removed. (HFA.)

After bulldozers scraped away the mangrove and scrub wilderness, the city of Cape Coral expanded in canal-bordered quadrilateral patterns. (FPC.)

Four

Life along the Caloosahatchee

Apart from its functions as transportation artery and water source, the Caloosahatchee provides something less easy to define to those who live near or visit it.

For fishermen, the river offers itself as a premiere recreation destination. The late-1800s revelation that tarpon, a sought-after game fish, could be caught in the Caloosahatchee by hand on a rod and reel ignited tarpon fever, which brought thousands of competitive anglers to the region in pursuit of the mighty silver king. In 1889, sport fisherman O.A. Mygatt wrote, "Verily, the lover's jealousy may be a green-eyed monster, but compared with the jealousy of a tarpon fisherman towards his brother sportsman it counteth as nothing."

For nature watchers, the river is rich with life—"A veritable land of delight," is how the 1912 *Guide to Florida for Tourists, Sportsmen, and Settlers* described it. "The varied scene, the long reaches of greenery of every kind, the sheets of water with picturesque tropic islands, the knowledge that the feathered, furred, and finned inhabitants of land and water have been practically undisturbed by civilized man enhance the charm to the sportsman and tourist."

Civilized man has certainly made himself felt in the last century; even so, the charm remains. Just ask a rope-swinging child in one of the river's oxbows, a plein air watercolorist painting an old bridge, or a couple strolling through a guava-tinted sunset: the Caloosahatchee can be a source of joy, inspiration, and renewal.

Its sheer physical beauty helps create the region's subtropical mise-en-scène. Ancient gar still glide through waterlilies, Spanish moss still cascades in rippling silver reflections, and spear-beaked herons still stalk the shallows as the Caloosahatchee creates a singular sense of place that seeps into the soul.

Black-haired, dark-eyed, and almost six feet tall, Spanish-born Manuel A. Gonzalez piloted a mailboat that ran from Tampa to the Army garrison at Fort Myers until the Civil War made that impossible. After the war ended in 1865, he returned to settle along the river and open a trading post. When he died in February 1902, a gale wind was blowing, a fact not lost on the anonymous writer who penned his obituary for the *Fort Myers Press*: "just such a storm as the veteran whose life was ending had encountered time and again at sea. . . . For more than a year past he had been failing and steadily losing the strength that a fine physique had given him through a long career as a seafaring man. . . . The name of Capt. Gonzalez will last as long as the history of Fort Myers is preserved. His life has been identified with its growth and development. Living through the early pioneer days to see the town grow into a beautiful city of homes, there have been none to say aught against the character of this reliable and honest citizen." (HFA.)

Manuel Gonzalez's 1897 license as a first-class steamer pilot was the 12th issued in the state of Florida. (HFA.)

By the 1880s, about 50 families had settled in the pine-forested area between 10 and 15 miles upriver from Fort Myers, the Olga-Alva region. Most made their living growing vegetables and citrus, and most of their homesteads boasted sturdy wooden docks so crops could be loaded and ferried to market. (HFA.)

Once a center of citrus production along the Caloosahatchee with its own Baptist church and post office, Owanita now is a ghost town, though its name survives on a Lee County street sign. In the 1870s, Massachusetts-born George Theron Raymond arrived with his wife, Clara. Here he built a church, planted citrus, opened a post office (as postmaster, he earned $126 a year, according to the post office's 1907 official register), and ran a cooperative packinghouse he passed on to his son Wilfred. The abandoned chapel was later moved to Alva and connected to the old library building to become part of the Alva Museum. (HFA.)

Along with his widowed mother and seven brothers and sisters, John C. English came from Georgia to homestead on the Caloosahatchee. They raised cattle, planted row crops, and grew citrus. Eventually, the family built this packinghouse on the river. In a 1939 interview done for the Federal Writers Project, English recalled the early days: "It was several years before we shipped any fruit to amount to anything. . . . The early fruit was pulled and loaded in bulk in schooners. About $4 a thousand was the ruling price for oranges." (FPC.)

A note on this 1910 photograph of a Caloosahatchee fishing boat says it was taken at Hurd's landing between Fort Denaud and La Belle. (FPC.)

The people in this rowboat on the Caloosahatchee are identified, from left to right, as Mrs. Charles O'Bannon, Irby Clay, Charles O'Bannon, and Laura Belle Blackburn. (FPC.)

These fishing nets are set out to dry at Punta Rassa at the mouth of the Caloosahatchee. In 1884, a bulletin of the US Fish Commission reported, "There is a mullet fishery here. . . . The gangs, called fishing ranches, consist of 13 men each, mostly Spaniards, with two boats for each company. Nets are used. . . . [The catch is] rough-salted and sent to Cuba." (HFA.)

Barrett's store at Punta Rassa, owned by Howard and Juanita Barrett, was a lonely outpost near the mouth of the Caloosahatchee in the 1940s, when this photograph was taken. (HFA.)

The inscription on this photograph boasts that this array of giant tarpon was "caught by O.A. Mygatt with rod and reel in one day at [Fort] Myers, Florida in 7 hours." It was Mygatt, a fishing writer, who quipped, "Verily, the lover's jealousy may be a green-eyed monster, but compared with the jealousy of a tarpon fisherman towards his brother sportsman it counteth as nothing." (HFA.)

Until it was destroyed by fire in the 1940s, Fort Myers boasted the largest packinghouse in the world. Built out over the Caloosahatchee, it was where farmers took their row crops—eggplants, tomatoes, and potatoes—along with citrus to be graded, packed, and sent around the country. (HFA.)

The Tarpon Street Pier in Fort Myers has long been a popular spot for anglers and picnickers. (Author's collection.)

Built in 1838 as one of the supply depots along the Caloosahatchee River during the Second Seminole War, Fort Thompson was named for Lt. Col. Alexander R. Thompson, who was killed in the Battle of Okeechobee on Christmas Day, 1837. (HFA.)

This is a c. 1920 view from downtown Fort Myers facing north at Jackson Street, looking toward the old city docks. (HFA.)

Every year, LaBelle celebrates Florida's state tree with its Swamp Cabbage Festival, featuring the sabal palm's edible heart served in a variety of traditional dishes as well as live music and a parade. (SNG.)

LaBelle's riverfront Barron Park is the site of its annual Swamp Cabbage Festival, which celebrates the edible heart of Florida's state tree, the sabal palm. (SNG.)

After a 1926 lynching in LaBelle, lightning struck the Hendry County courthouse clock tower several times, ruining its inner workings. By 1930, the city had disassembled the mechanism and removed the clock's hands. LaBelle was called "the town where time stands still" for the next several decades, but in 1975, to celebrate country's bicentennial, the clock was restored. (HFA.)

Spanish moss drapes the huge live oaks that line many streets in LaBelle, a Caloosahatchee riverfront city rich in old Florida character. (HFA.)

Descendants of Capt. Manuel A. Gonzalez gather at the family homestead on the Caloosahatchee in this undated photograph. (HFA.)

Pioneering Hendry County developer Edgar Everett Goodno experimented with several types of cattle in Southwest Florida. Credited with introducing the heat-tolerant Indian Brahma variety to the region, he also imported European cattle, including Black Angus and this curly-coated specimen, which appears to be a Galloway bull. (HFA.)

Located at the mouth of the Caloosahatchee where it empties into San Carlos Bay, Punta Rassa was once the major port from which cattle was shipped. The area later became the capital of the tarpon-fishing industry thanks to George Shultz's famous Tarpon House hotel. (HFA.)

Nicknamed "America's Sweetest Town" because it was the headquarters of the US Sugar Corporation, Clewiston sits on the bank of Lake Okeechobee where the Caloosahatchee begins. (HFA.)

Near Lake Okeechobee, yellow lotus flowers once grew in such profusion that entrepreneurs would pick them during the late summer flowering season. In this undated photograph, harvesters use an airboat to reach the pods, which later would be sold for use in dried flower arrangements. The *Palm Beach Post* reported in 1987 that each pod was worth 50¢. (SNG.)

This aerial photograph of the Caloosahatchee riverfront shows the city's yacht basin and a high-rise apartment building for retirees. (HFA.)

The piled-up hay in this photograph from about 1911 of a young Alva citrus grove may have been stored as insulating defense against freezes or as forage for cattle. (FPC.)

Henry Ford bought his Caloosahatchee riverfront home in Fort Myers next door to that of his friend Thomas Edison. After Edison died in 1931, Ford's visits became infrequent, and he sold the house to Thomas and Gladys Biggar in 1945. This is the view of the porch while the Biggars owned it. (SNG.)

Known as the silver king, tarpon is a prized game fish that swims the Caloosahatchee. In 1885, *Forest and Stream* magazine reported that a New Yorker named W.H. Wood had caught a tarpon in the Caloosahatchee with nothing but a rod and reel, a feat that lured thousands to the region in hopes of replicating it and thereby spawning an industry. The happy angler in this 1959 photograph is Frank LaRose of Ohio with a 170-pound specimen he pulled from the river. (HFA.)

Over the years, several boats turned restaurants have anchored in the Caloosahatchee. In the 1980s, Captain Walt's Floating Seafood Restaurant lured hungry diners to the Fort Myers Yacht Basin, where it was anchored. (SNG.)

One of the Caloosahatchee's tributaries, the Orange River, flows through a settlement known as Buckingham. The Menge brothers had their boatworks at the confluence of the two rivers. (HFA.)

Iowa banker and developer Nelson Burroughs bought this grand mansion on the Caloosahatchee in 1919. This photograph, which shows him with his wife, Adeline, and daughters Jettie and Mona (in the hammock), was taken soon afterwards. (UFF.)

Nelson Burroughs, his daughters Mona (left) and Jettie (right), and their mother, Adeline, stand in front of a large date palm that was part of the tropical landscape of their Fort Myers home. (UFF.)

The Buena Vista Country Club's pier stretched into the Caloosahatchee near Whiskey Creek west of Fort Myers. (HFA.)

In the river's saltwater portions, schools of mullet and other small fish are present, and anglers often begin their mornings by tossing a cast net to catch a day's supply of bait. (Author's collection.)

Christmas in Fort Myers in 1885 was marked by an informal tournament that included horseback races. The back of the photograph says the rider is named L.C. Hibble, and his mount is Old Sam. (HFA.)

Contrary to local legend that says Thomas Edison so prized his peace that sometimes he would not bother to bait his hook, the inventor enjoyed fishing on the Caloosahatchee during his winter sojourns to Fort Myers. (HFA.)

With a posted speed limit of 25 miles per hour, the Edison Bridge crosses the Caloosahatchee in view of this gracious riverfront backyard. (UFF.)

In 1966, a barge hauling rocket parts to the Kennedy Space Center crashed into Alva's swing bridge, and it had to be replaced. (US Army Corps of Engineers.)

As if newspaper photographs of monster tarpon were not enticement enough, the postcard industry also contributed to the success of the Caloosahatchee region's tourist industry. (SNG.)

The popular Cape Coral Yacht Club opened in 1960 with a pier stretching 264 feet into the Caloosahatchee River. (HFA.)

This photograph shows the Hanson and Petzold families enjoying an upriver boating party. (HFA.)

Thomas Edison was first attracted to Fort Myers because of its fine stands of bamboo, one of the plants he was investigating as a potential source of lightbulb filaments. As the years went on, though, work in his Fort Myers laboratory (pictured) focused on plants that might be used to produce rubber domestically. (HFA.)

By the early 1900s, gracious homes began appearing along the Caloosahatchee. Capt. Manuel A. Gonzalez built one of the first, shown in this 1901 photograph. The captain stands on the front porch; upstairs, from left to right, are his children, William, Laura, and Alfonso Gonzalez. (HFA.)

Another postcard promoting the excellent fishing in Fort Myers shows that the big fish in the Caloosahatchee could sometimes get a bit too big. (SNG.)

Dr. Franklin Miles, creator of Alka Seltzer, bought property and built a home along the Caloosahatchee River. He planted crops, and his fruit—especially his pineapples—became renowned throughout the country. (HFA.)

Housed in a building that was once the river town of Alva's library, the Owanita Baptist Chapel was added to the tiny Alva Museum, which features artifacts from the Calusa Indians alongside those of the town's early settlers. (Author's collection.)

Also known as the Hancock Bridge, the US 41 bridge from downtown Fort Myers to North Fort Myers is one of the busiest Caloosahatchee crossings. (HFA.)

At the mouth of the Caloosahatchee, where it empties into San Carlos Bay, telegrapher turned innkeeper George Shultz ran his famed Tarpon House hotel, where sportsmen and luminaries from around the country would come to hunt the "Silver King." (HFA.)

The *Lazy Bones* was a popular "shanty boat" (chartered in this 1959 photograph by a group of college students) that traveled the Caloosahatchee and its tributaries from Fort Myers to Lake Okeechobee. According to a 1966 *New York Times* travel story: "Florida shanty boat is a motel afloat; six-day trip costs $125 and stresses informality. . . . Boating enthusiasts who have a high sense of adventure but lack the physical stamina to indulge it will discover that a shanty boat is the only way to float." (FPC.)

In 1927, Fort Myers built the Pleasure Pier, a splendid, sprawling, Moorish-style multipurpose venue stretching into the Caloosahatchee. Complete with a swimming pool, a gymnasium, and a stage, many still recall hearing live concerts there, dancing to big band music under the stars, or simply listening to the river lapping against the pilings. Inside, the pier was decorated with a series of "Alice in Wonderland" mural panels. Mildred Hooker of Fort Myers served as the model for Alice. (City of Fort Myers.)

Young Mildred Hooker is pictured with the painted "Alice in Wonderland" panels that decorated the Pleasure Pier on the Caloosahatchee in Fort Myers. (City of Fort Myers.)

It was in the Caloosahatchee River near Punta Rassa that the first tarpon was caught with rod and reel in 1885, an event that began a boom. (HFA.)

Anglers have been heading out to the end of the Tarpon Street Pier for decades. (Author's collection.)

The 1902 Report of the Chief of Engineers of the US Army described the Caloosahatchee's headwaters as surrounded by marshes. "Being shallow, the growth of bogrush, cat-tails, bonnets, and flags covers a large portion of their bottoms, and water lettuce and lovers' vines run over many acres of their surface. . . . A beautiful grassy prairie commences below Lake Flirt and extends to the wooded region at Fort Thompson. From there to the mouth of the Caloosahatchee River is a finely wooded country. . . . From Alva to the mouth of the Caloosahatchee are great patches of water hyacinth and water lettuce." Fifteen years later, naturalist John Kunkel Small photographed this dense growth of water hyacinths choking a Caloosahatchee tributary. (FPC.)

Although this hand-colored postcard of a scenic spot on the upper Caloosahatchee is undated, it bears a 1912 postmark. (FPC.)

This undated photograph shows the wedding party of banker F. Watts Hall and Alice Baldwin at the Methodist church at Fort Denaud. After a 1926 lynching, Watts was one of the townsmen who pursued prosecution of those in the mob. (HFA.)

Early packinghouses were often quickly constructed with available materials—usually fronds of the sabal palm, which grew in abundance—and located close enough to the river so that fruit could easily be loaded into boats, as this photograph from about 1916 shows. (FPC.)

One of the most elaborate vessels to travel the Caloosahatchee during the river's steamboat heyday was the *Thomas A. Edison*, an elegant stern-wheeler owned by the Menge brothers. (FPC.)

Alva's first store is pictured about 1900, according to the handwritten caption on the back of this photograph from the Alva Historical Society's collection. Although not all the people pictured are identified, the names in the caption are, from left to right, (first row) Bob Dean, Sam Bruton, Lee Edwards, Mrs. Bruton, W.W. Raymond, and Cecil Parkinson (barefoot); (second row) unidentified, Ben Clay, Mrs. Adams, Miss Norman, unidentified, and Jim English. Maymie Edwards Clay is standing next to carriage. (AM.)

Shovels, hoes, and mules were the beginning of Highway 80, according to the penciled caption on the photograph, which also says it was taken in front of Mr. Snyder's. Now known State Road 80, it runs parallel to the Caloosahatchee through much of Lee, Hendry, and Glades Counties. (AM.)

Watermelons and sea turtles? One could find it all at Blount's General Store in downtown Fort Myers. (FPC.)

For decades, this riverfront general store in Alva kept fishermen supplied with bait and tackle and kids supplied with candy until it was destroyed in a fire. (AM.)

Flora English Watkins was about 18 in 1910, when this photograph of her paddling a dugout Indian canoe on the Caloosahatchee was taken. (FPC.)

In this undated photograph, children along the Alva riverfront watch boats on the Caloosahatchee, as those who love the river hope they'll do for generations to come. (FPC.)

DISCOVER THOUSANDS OF LOCAL HISTORY BOOKS FEATURING MILLIONS OF VINTAGE IMAGES

Arcadia Publishing, the leading local history publisher in the United States, is committed to making history accessible and meaningful through publishing books that celebrate and preserve the heritage of America's people and places.

Find more books like this at
www.arcadiapublishing.com

Search for your hometown history, your old stomping grounds, and even your favorite sports team.

Consistent with our mission to preserve history on a local level, this book was printed in South Carolina on American-made paper and manufactured entirely in the United States. Products carrying the accredited Forest Stewardship Council (FSC) label are printed on 100 percent FSC-certified paper.

MADE IN THE USA